To Elfa, my wife and guiding light for 50 years.

42 ENCOUNTERS
IN SAN FRANCISCO

MANNY KAGAN

ENCOUNTERS
PUBLISHING

Encounters Publishing
2171 Junipero Serra Blvd., Ste. #300
Daly City, CA 94014

www.EncountersPublishing.com

www.42Encounters.com

2016©MannyKagan All rights reserved

Photographs and essays by ©MannyKagan

Book design by Darren Young

Edited by Amy Bauman

First Edition

Printed in the United States of Americaa

Library of Congress Control Number: 2016902314

ISBN-10: 0-9971861-0-0

ISBN-13: 978-0-9971861-0-9

TABLE OF CONTENTS

INTRODUCTION

Thirty-five years ago, I fell in love. At that time I had been happily married for thirteen years, we had two children, and our family had just moved to San Francisco. It was there I fell in love—with the city.

My wife, Elfa, our older daughter, Alona, and I were born in Riga, Latvia. From there, together with my wife's mother, we immigrated to Israel, where our younger daughter, Tamar was born. Eight and a half years later, life uprooted us again, and in August 1980, we moved to America to expand our education. We knew only one person in San Francisco when we arrived: my wife's childhood friend. We asked her to find us a cheap hotel for our arrival, and she found one in the heart of the Tenderloin neighborhood. One of the stories I heard about how the Tenderloin got its name is that one hundred years ago it was so dangerous to live and to work there that policemen were paid extra, which allowed them to afford tenderloin steaks.

Our hotel was located on Leavenworth and Ellis streets. We were jet lagged and could not sleep that night, so we looked out the window, watching as the women below (whose occupation goes to the pre-historic times) invited men to have a good time in our hotel. The following morning, holding our children's hands tightly, we ventured out and were greeted by a welcoming committee of unwashed, strange-looking people.

Over the next week, as we tried to find an apartment to rent, we discovered that San Francisco is a special city, populated by beautiful people with whom I have fallen in love. This book, full of my photos, my reflections, and some historical notes, is just my way of saying, "Thank you." I want to thank those pioneers who came here driven by the gold rush. They laid the foundation for the small village of Yerba Buena, which in 1847 had population of 812 people, to become the great city of San Francisco. Our city's street names keep their names alive.

I have been taking photographs since my childhood in Riga. At that time, I primarily took photos of my family. In early 2000, I received my first digital camera, and it changed the way I look at the world. It took several years and a number of technological improvements before I started to carry my camera with me everywhere. Then I became fascinated with photographing people on the streets, and Elfa would constantly ask me why I was taking photographs of strangers. Needless to say, I was not so easy to travel with. She would walk forward, and I would stop to have another click. After years of her tolerant complaining, I gave her one of my cameras on our first trip to Cuba, and since then, I have to wait for her every time she stops to photograph something.

I do not have a formal photography education outside of some photo courses that I took at the City College of San Francisco and a few workshops. I also was privileged to take classes from renowned photographers and teachers such as Jay Maisel and Joel Meyerowitz. The rest of what I know I learned from photography books and practice. After our first trip to Cuba, I decided to put some of the images I'd photographed into my first photo book, *"Soy Cubano"*.

A few years ago, I wrote two books about the mortgage business. This business has supported both my family and my photo hobby for more than thirty years. In the process of writing the books, I discovered that I like to write stories. As a result, I began to publish an online newsletter each Friday titled, "My Encounters." Each week I share a story from my life or something I have learned from reading or speaking with someone, and I include four of my photo images to give my writing added life. You can find them at mannykagan.com.

Some readers suggested that I should put those encounters in this book. Instead I decided to create an entire body of work. The book you are holding is the first of a series that I am planning to create called "42 Encounters™."

Creating the series with the number forty-two also has a story. In spring 2015 at the Santa Fe Photographic Workshop, I participated in a class taught by the well-known National Geographic photographer Sam Abel, who is an excellent teacher. Somehow, during our first meeting, the number forty-two came up. One of the lessons was about being selective with our photography work—the idea that "less is more." Toward the end of the workshop, I showed Sam some images for a book I was working on, in which I planned to use eighty-eight images. He liked my photos but suggested I edit them down to forty-two images. Later on when I returned home, I found the number forty-two in *"The Hitchhiker's Guide"* to the Galaxy by Douglas Adams as "The answer to the ultimate questions of life, the universe, and everything."

In my photography work, I try to follow the footsteps of the talented women and men whose photography I admire. Many of them were or are members of the Magnum Photos international cooperative. One of them, the great living photographer Elliott Erwitt, wrote (in one of his photography books) that he is an "amateur" photographer, (in French "amateur"—"lover of"). In his photo book *"Between the Sexes"* he wrote: "The kind of photography I like to do, capturing the moment, is very much like that break in the clouds. In a flash, a wonderful picture seems to come out of nowhere." This is my style as well, and I call it "encounter photography."

Please enjoy my book and share it with a friend.

Manny Kagan
Amateur Photographer

September 2016

1

HOW TO BE SAVED

There is a Russian proverb, *"Na boga nadeysya a sam ne ploshay,"* which translates to, "Hope for God but do not be reliant." It is similar to the teachings of Hillel the Elder, a Jewish religious scholar, who lived two thousand years ago in Jerusalem: "If I am not for myself, who will be for me?" Can God or Jesus save us, or must we rely on ourselves?

And, if we are the sinners, how do we repent? Is it enough to proclaim "Father, I have sinned" and then go back to the old habits? Or is it sufficient, as Jews do once a year on Yom Kippur, the Jewish Day of Atonement, to spend the whole day in the synagogue, praying in the Hebrew language without understanding the words' true meaning, and ask for forgiveness?

I do not think that anyone can honestly answer these questions. For most of us, our lives just happen, and we are too busy to worry about being saved. But some people are committed to our souls being saved, which is probably why this man, placard and megaphone in hand, stands on the busy corner of Market and Powell streets, the last stop of the city's cable car system.

The San Francisco cable car system started its operation in 1878 and used to have twenty-three lines. In January 1947, the mayor of San Francisco decided to get rid of cable cars. The last three lines were saved through the efforts of the San Francisco matron, Friedel Klaussman, the "cable car lady." In 1964, San Francisco's cable car system became a moving national landmark.

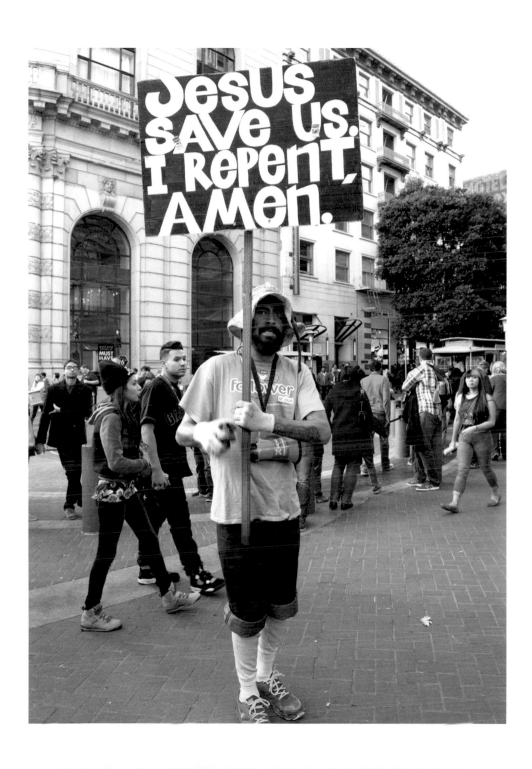

2

BICYCLING

Bicycles were introduced in the nineteenth century in Europe, and, by 2003, more than a billion had been produced worldwide. Among the twenty bike-friendly cities in the world, Amsterdam in the Netherlands, which I visited in 2007, ranked number two in 2015. I felt very comfortable walking there and took a great number of photos of bikes and bicyclists.

Bicycles have become more sophisticated and more expensive over the years. Although some bicyclists wear special gear and clothing, some actually prefer to ride naked, being part of international clothing-optional bike ride movement. These bikers ride together en masse, on human-powered transport, and belong to the World Naked Bike Ride (WNBR) organization. The first organized event took place in 2004 in twenty-eight cities and ten countries. By 2010, WNBR members were riding in seventy-four cities across seventeen countries.

I met a WNBR group in San Francisco on the Embarcadero, not far from the Justin Herman Plaza. *Embarcadero* comes from the Spanish verb *embarcar*—which means "to embark." That fits perfectly well with those who embark to be noticed. Of course, I took images from the front of the group as well but decided to spare this publication from those.

Justin Herman Plaza, which opened in 1972, is named for .M Justin Herman, who was executive director of San Francisco Redevelopment agency until 1971. Besides the Vaillancourt Fountain, it is famous for the Critical Mass bicycle rides, whose riders have gathered in the plaza for more then twenty years.

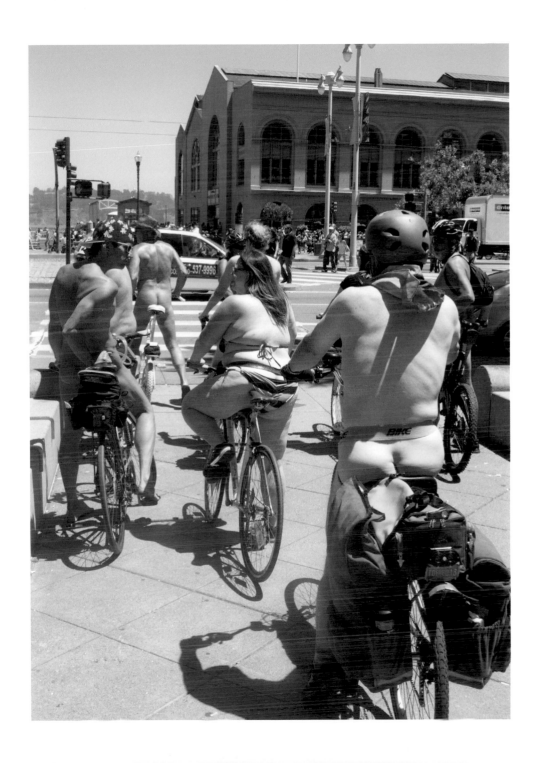

3

PIGEONS

Pigeons recently made the news when it was reported that senior clerics fighting for the Islamic State of Iraq and al-Sham (ISIS) in Syria and Iraq issued an instruction to ban pigeon breeding, claiming "the sight of the birds' genitals as they fly overhead is offensive to Islam." According to the Torah, birds were created on the fifth day. "And God created . . . all winged fowl of every kind. And God saw that it was good" (Genesis 1:21). Also in the Torah, there is a story about the deluge and Noah's ark. To learn whether there was dry land to be found, Noah sent a dove, which returned with an olive branch. The artist Pablo Picasso used this theme and drew a dove as a symbol of peace.

The word pigeon comes from the French language, while dove is a Germanic word. Regardless what we call them, these birds have been around for a long time and have served humanity in many ways: from ritual sacrifice, to messengers and spies, to plate cleaners in restaurants. I encountered this pigeon at Le Boulanger restaurant at the edge of the Yerba Buena Gardens, a name that means "good herb" in Spanish. Yerba Buena was originally the name of the Spanish village, which became the city of San Francisco in 1848.

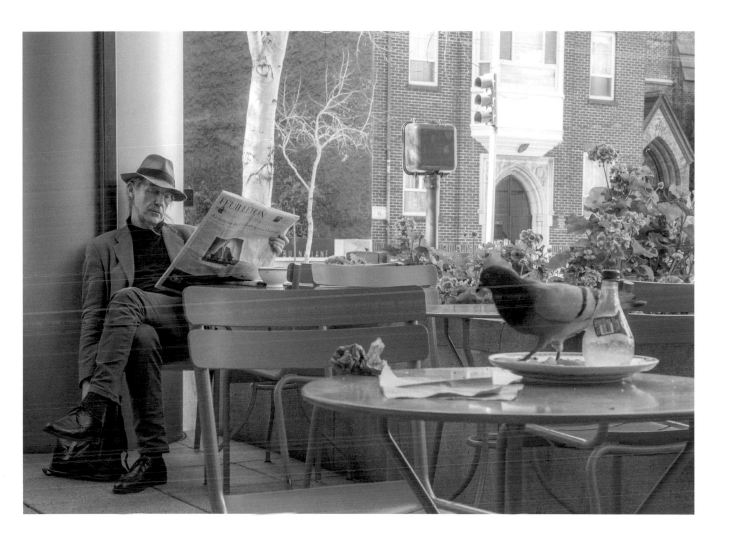

4

PAYPHONE

It's commonly known that Alexander Graham Bell and his associate Thomas A. Watson invented the modern electronic telephone. But Mr. Bell was also a very good businessman. The Bell Telephone Company was organized in 1877, went on to merge with other companies, and grew to become the American Telephone and Telegraph Company (AT&T), which at times was the world's largest telephone company.

We are accustomed to having phones in our homes and offices. But what if there were no connection to the network? This was our situation in 1977 when we lived in a remote village in Israel. The only connection with the outside world was a pay phone a few blocks away from our house. When I worked late, my wife would use that phone to call me to find out what time I would be coming home for dinner. It is difficult to believe, but there was a time when we did not have cell phones. But pay phones are still around—and sometimes people even use them. I took this photograph on West Portal Avenue not far from Wawona Street.

According to some authorities, Wawona is the Native American word for "big tree." Giant Sequoia trees (like the Wawona Tree) can be found in Yosemite National Park. It might be surprising that a San Francisco street is named after the Wawona Tree. However big trees, like big businesses and big cities, start from a small seed and take time to grow and develop.

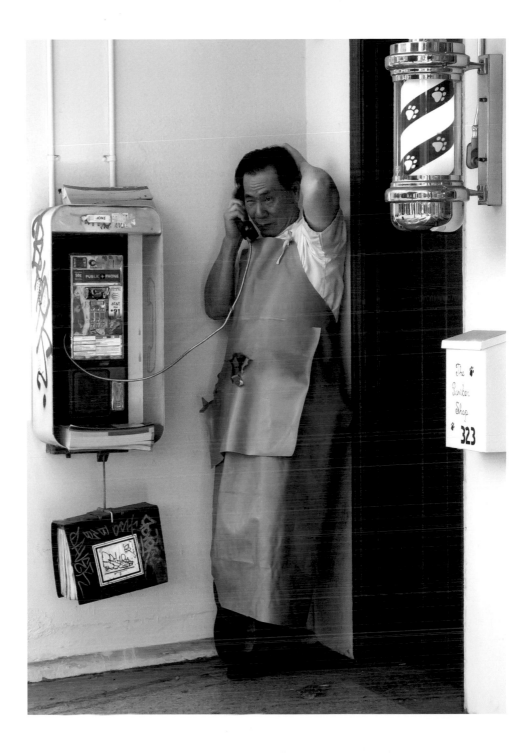

5

RECYCLE

I used to enjoy visiting Haight Street, where I would sometimes read or write in the People's Café while drinking tea; or sometimes I would especially visit this street to photograph. A mixed group of people, both locals and tourists frequent the café; some come for the food, others come to relax. It seems people want to immerse themselves in the energy of the "hippie history" of the Haight-Ashbury.

One group of regular visitors especially stands out to the area. Their disheveled clothes and unwashed, smelly bodies make them easy to recognize. You see them aimlessly walking the streets or sitting on the pavement until the policemen arrive. Then they move on toward Golden Gate Park with all their worldly possessions in their backpacks and often accompanied by a dog. With their "exotic" looks, they are easy models. Many do not mind being photographed; some ask for a dollar to buy weed in exchange. One day, I encountered a young woman sitting in the bin for recyclable garbage. After seeing me with the camera, she smiled and flashed a victory sign with her dirty fingers. How did she get in? Why did she go in? Later on, I photographed her sitting on the pavement with her equally unwashed friends.

In San Francisco, recycling is a big business. We locals divide our refuse into three groups so that we can make maximum use of the discarded materials. But what should we do with people who sit in the recycle bins?

You probably heard about the role The Haight, as the area is sometimes called, played during the "hippie" era. It is difficult to imagine that before the completion of the Haight Street Cable Railroad in 1883, this area was a collection of isolated farms and sand dunes.

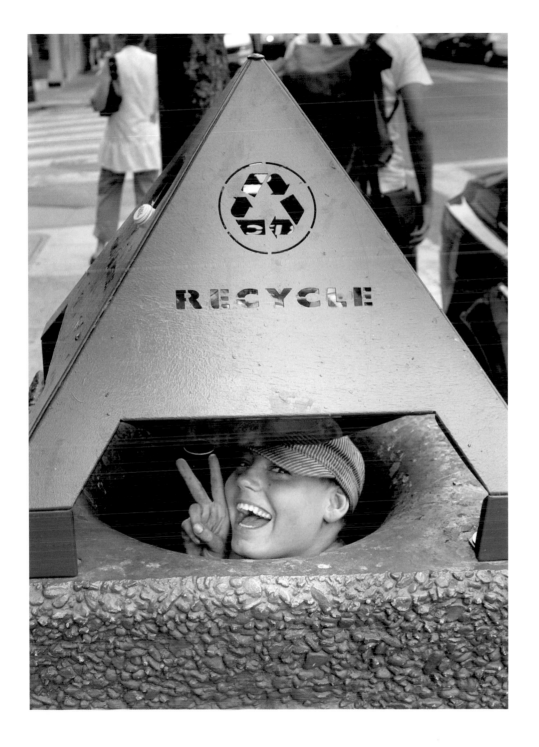

6

POET

I recently had a client who studied in college to become a poet. However, to be able to have a family, buy a house, and take on a mortgage, he became a salesperson instead.

This brought to mind that, when I was about six years old, my uncle asked me what I wanted to be when I grew up. (How many people can answer this question even later on in their years?) My response was "a pilot or a poet." Was this just childish talk? I do not want to think so. After all, as a mortgage broker, I fly high in helping people to solve their lives' problems. Does it equate to the challenges that a pilot faces? As far as poetry goes, perhaps my stories and photography are my poetic expressions. You be the judge.

It is not easy to be a poet, but it seems that some people can make a living writing poems, like the fellow I met in front of the Ferry Building. The building, with its interesting shops and restaurants and the farmers market, draws big crowds of tourists and locals—but I guess that's not what all people come for.

San Francisco is privileged to have an independent bookstore-publisher City Lights, which was founded in 1953 by poet Lawrence Ferlinghetti. This is the place where poets such as Allen Ginsberg were first published.

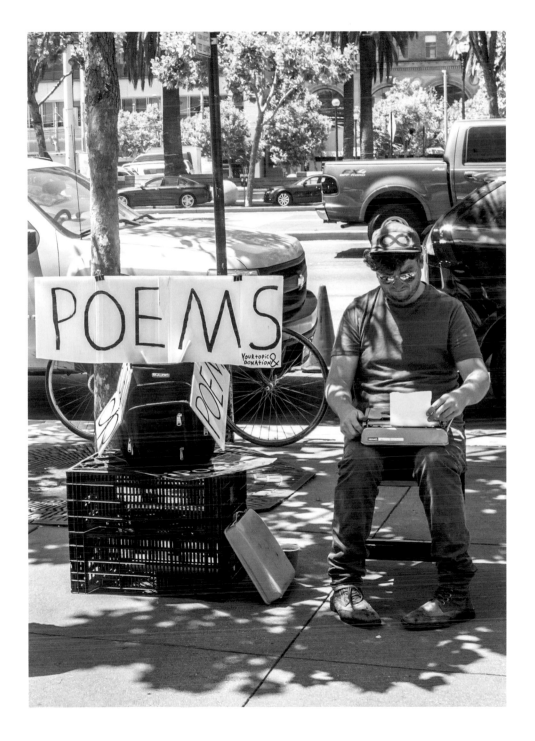

7

SPORTS

When I was younger, we played soccer, volleyball, basketball, Ping-Pong, and tennis. Sports were just a game. At school, we ran, jumped, and climbed rope. When I was a little older, I learned Roman wrestling, fencing, and in college, mountain climbing. I was never very good at any of these activities, but I had a good time playing and practicing them with my friends. We didn't care about having fancy shoes or cool-looking clothing to go with the sport; that wasn't what the sport was about.

The sports industry became a huge shoe and clothing business. with different kinds of activities and performances, like the one I encountered at the Union Square for Nike shoes. At least it seems that the woman had fun jumping for a photo opp.

Union Square got its name because it was once a place for rallying in support of the Union Army during the American Civil War from 1861 to 1865. Today, Union Square retains its role as the ceremonial "heart" of San Francisco, serving as the site of many public events and celebrations.

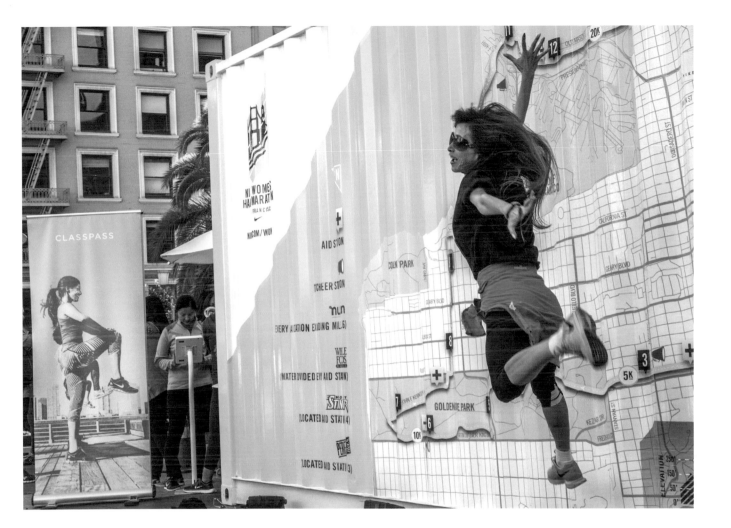

EMPEROR NORTON

Many people today probably do not know that there was an emperor in San Francisco from 1859 until 1880. Joshua Abraham Norton was born in London in 1818. He spent most of his early life in South Africa and then immigrated to San Francisco in 1849. In 1859, after losing his fortune by investing in Peruvian rice, he proclaimed himself "Norton I, Emperor of the United States" and later, on "Protector of Mexico."

Some people considered Emperor Norton eccentric; others said he was crazy. But he was also a visionary. One of his decrees was to build a bridge over the bay and a tunnel under the bay, linking San Francisco to Oakland. It took many years for his decree to be executed, but it did happen. Unfortunately for Emperor Norton, it all happened long after his death and funeral in 1880, which was attended by thousands of San Franciscans.

Through the years, a number of "emperor" impersonators have entertained the public in downtown San Francisco. I met "Emperor Norton," pictured here, next to the Hair Salon on Grant Street. The emperor regularly leads a historic walking tour, Emperor Norton's Fantastic San Francisco Time Machine, through San Francisco.

Ulysses S. Grant, whose name adorns every corner of this street, served as the president of the United States from 1869-1877 and may have heard about "The Emperor of the United States."

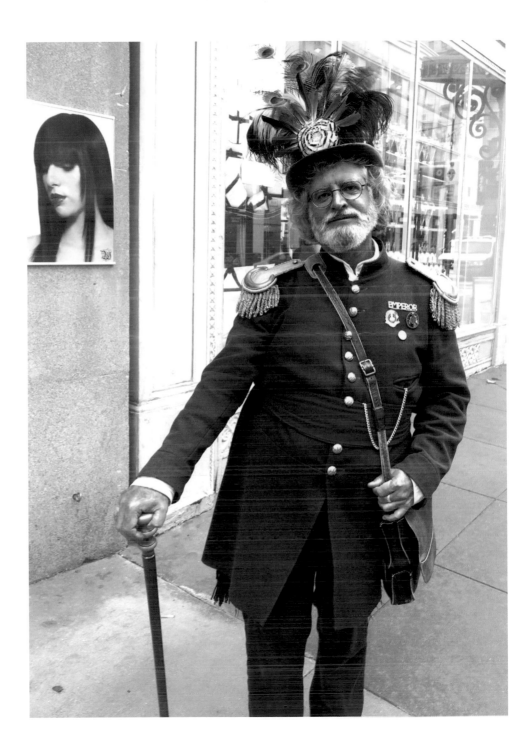

9

GIVING

It is written in the Bible, "Give, and it will be given to you" (Luke 6:38). But there is also the counsel, "If you lend to those from whom you expect to receive, what credit is that to you?" (Luke 6:34). How can we reconcile these two seemingly contradictory statements? In Hebrew, the word *"tzedakah"* refers to acts of charity, but the literal meaning is "justice or righteousness." Followers of many religions are obligated to give money to charities. But giving can take different forms. One way of giving is to give donations anonymously to unknown recipients. But an even higher form of giving is to give a gift or a loan or to offer a partnership that results in the recipient learning to support himself instead of depending upon others.

Every year around Christmas time, the Salvation Army has people standing (or sitting) in conspicuous spots around town, ringing their well-known bell to encourage people to give to help others. Regardless of your reason for giving, keep giving. (And you do not need to wait for Christmas to do it.)

I took this photo in front of the Shreve & Co. jewelry store. In 1893, Simon Shreve opened a small jewelry store, which has been in the Shreve Building on the corner of Post Street and Grant Avenue since 1906. It is one of the few buildings that survived the April 18, 1906, earthquake. Unfortunately the store has become victim of rising rents and moved out.

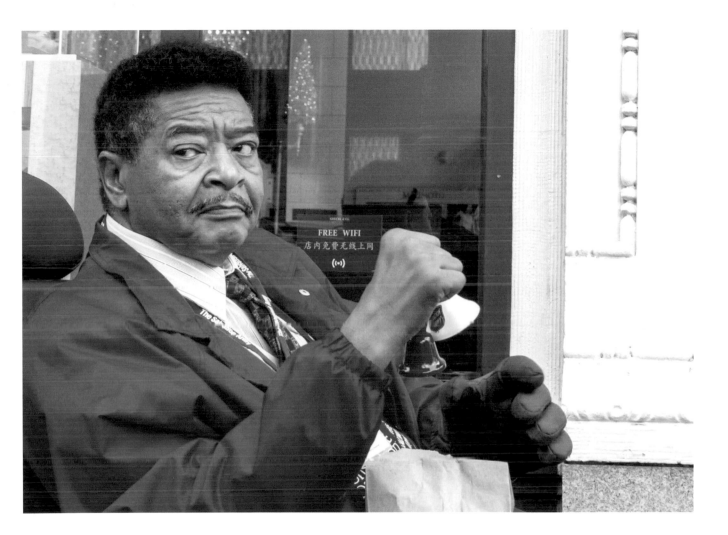

10

LEGS

I was coming from a business meeting on Clement Street and looking for a restaurant where I could have lunch when, suddenly out of the corner of my eye, I noticed a man with a wide-brimmed hat and a cane, limping nearby. He looked like a good candidate for a snapshot, but I continued searching for a good place to eat. When I next turned around, the man was sitting on the bench conversing with a friend. From where I stood, it looked as if he had three legs.

At this moment (while I looked for the right angle from which to shoot), I remembered a story about a man who complained about having no shoes until he met a man who had no legs. Most of us have both legs. But when was the last time you took notice of them? Probably it was the last time they were aching. Meanwhile our legs are working very hard for our benefit. Don't you think it's about time to show them some gratitude? Pamper your legs—massage them, give them a warm bath—and just say "Thank you."

Roswell Percival Clement, for whom the street is named, was a member of the San Francisco Board of Supervisors from 1865 to 1867. It was his idea to extend Golden Gate Park west to the ocean.

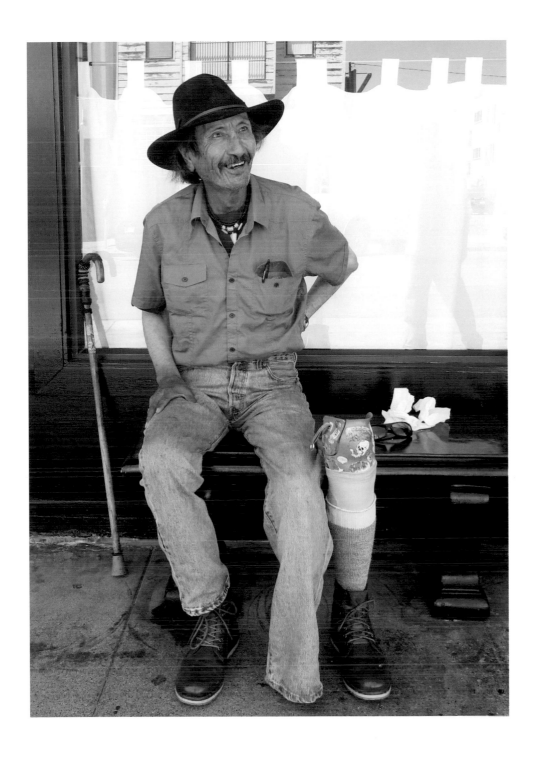

11

MARIJUANA

I read recently that college students are more likely to use marijuana than smoke cigarettes. Humans have always been drawn to methods of intoxication. During the early years in America, settlers drank fermented apple cider as water. When Chinese laborers first arrived in San Francisco, they brought opium dens with them. The Barbary Coast area, known as a red-light district, died out only after the area was destroyed in the 1906 earthquake. The hippie movement in the Haight–Ashbury District brought a Summer of Love together with LSD and other recreational drugs.

In spite of the weed usage restrictions, it is estimated that there were about twenty million marijuana users in the United States in 2013. Some people use it for medical reasons; others just like to have fun. It seemed that the man in green whom I encountered downtown, close to Union Street, was having a lot of fun selling his marijuana T-shirts.

Union Square was originally a tall sand dune, which was set aside in 1850 to be made into a public park. Today Union Square is a major tourist destination, one of the world's premier shopping centers.

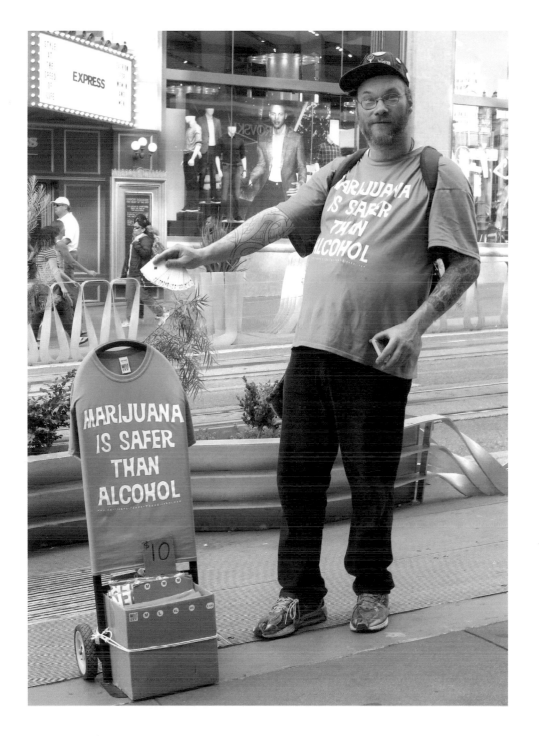

12

NEWSPAPERS

In 1690 Benjamin Harris published the first newspaper in the American colonies, *Publick Occurrences, Both Foreign and Domestick*. Only one edition came out before the government suppressed the paper. In 2009 the United States printed 1,387 daily newspapers, and San Francisco alone has more than eighty newspaper titles. Besides English, the city sees newspapers in Spanish, Russian, Japanese, Chinese, and probably other languages, to accommodate the diversity of our multicultural and multilingual city. I encountered a man napping over an open Chinese newspaper in Portsmouth Square, which is a popular gathering place for retired Chinatown residents.

The first known Chinese newspaper in America was Golden Hills News, established in 1854 — just six years after the first Chinese people arrived in San Francisco. Today, three major newspapers are printed in Chinese; they have a total circulation of 225,000, for the population of about 150,000.

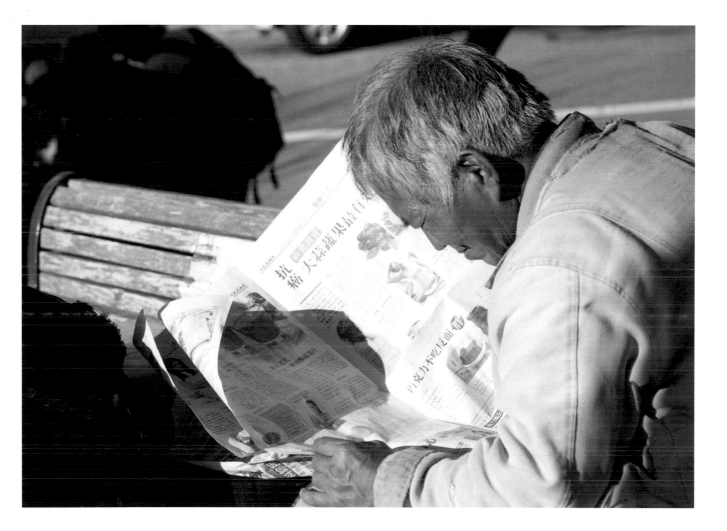

13

SENSE OF STYLE

Years ago I worked in an office in downtown San Francisco for Helga Howie, a women's high-fashion company. Though I was responsible for the company's operations, I was surrounded by beauty and style. When I ventured out during lunchtime, I often encountered the gray mass of men and women in business attire. Since then, clothing has become more casual. Even so, I still don't see many people who look stylish—a term that encompasses not only what clothing a person is wearing but also how he or she puts that clothing together.

What does it take to have a sense of style? Does one need to be born with it? Can a sense of style be learned? I do not have the answers, but I don't think that the young man I encountered at Tillman Place, a pedestrian alley located off Grant Avenue, needs assistance in styling.

The alley was named after Frank Joseph Tillman, one of San Francisco's pioneers, who came here in 1849. He knew how to live in style after acquiring a fortune in the safe building business. When he died in 1904 the obituary said, "Voyage Ends for Another Argonaut, Retired Capitalist Dies."

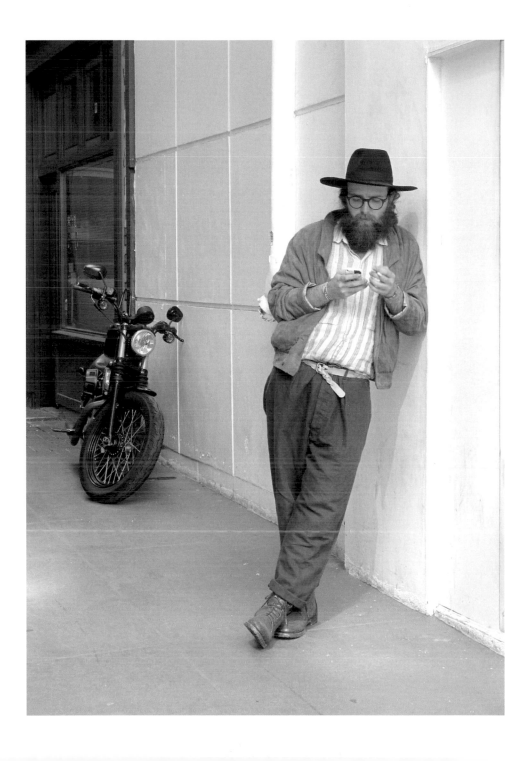

14

BUTTONS

Do you care to know why men's shirts have the buttons on the right, but women's blouses have the buttons on the left? Do you wonder who invented button-fly jeans? Do you know what a button-down shirt is? Answers for these and other button-related questions can be found on the Web.

Buttons have been around for about five thousand years. Items such as seashells and bones were originally used as decorations, but then around the thirteenth century, people started to use them as fastening devices, first in Germany. Then people began to use different materials: wood, metal, ivory, tortoiseshell. These buttons were useful, but they also continued to serve as decoration.

In the United States, buttons began to be mass-produced in 1812 as a means to supply the military with metal buttons. Today many buttons are made from plastic, and most of us do not think about or pay attention to them—at least not until we visit the Britex Fabrics store and encounter a wall covered with hundreds of buttons.

A San Francisco landmark since 1952, Britex Fabrics is located downtown on Geary Street. This street was named after John White Geary, who was elected the first mayor of San Francisco in 1850.

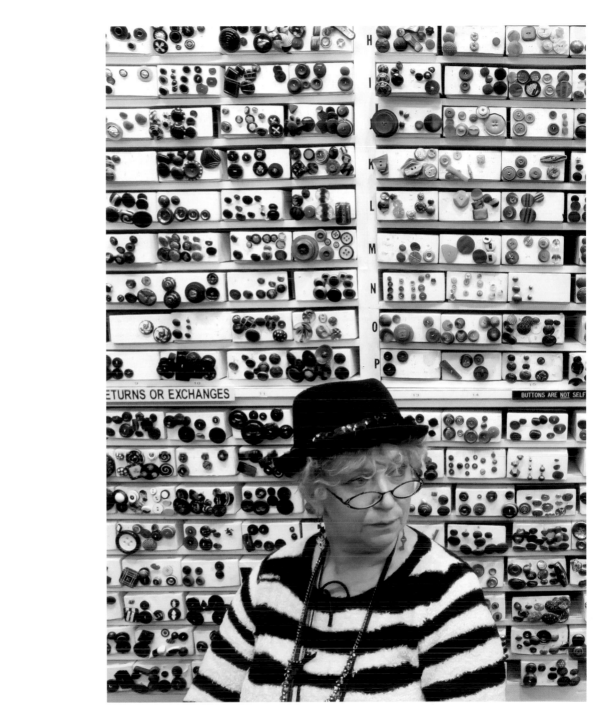

15

SOUL MUSIC

On Sunday mornings I often go for a walk around our neighborhood. Sometimes I head down the hill toward West Portal Avenue. During the day it is a busy commercial street, but on this Sunday at 8 am, there were only a few people on the street.

As I continued my walk, I suddenly heard the sounds of beautiful music. I wasn't sure where it was coming from, initially. I thought that perhaps it was someone's radio playing—but so early? As I came closer, the music filled me. And then I saw the source: a man, hidden in the doorway, was playing a guitar. When he saw me, he stopped playing and looked up. In his deep blue eyes, I saw sorrow and beauty. We did not exchange words; he was not asking for anything. I took a few shots and was on my way, but the music penetrated my soul.

West Portal Ave. has evolved after the construction of the "Twin Peaks Tunnel" which opened in February, 1918. It is 2.27 miles long and runs under Twin Peaks giving light rail streetcars a passageway between the east and west sides of San Francisco.

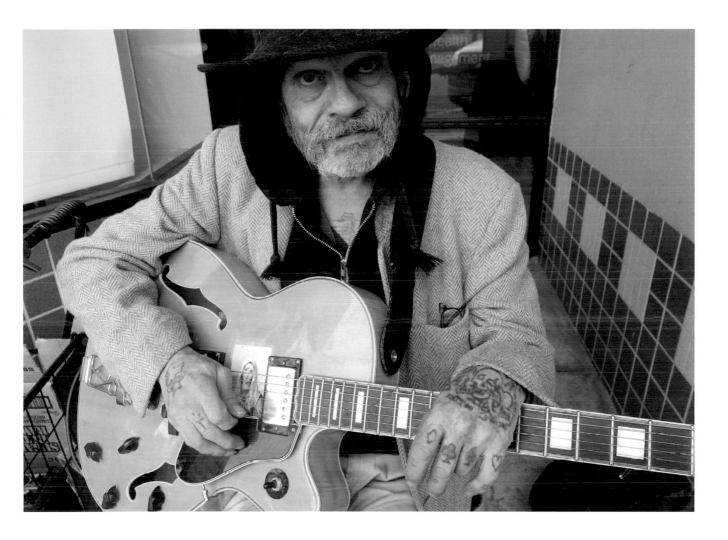

16

FOOTBALL

In my younger years, I played football. In some countries, as in the United States, the sport is known as soccer. Today soccer is played by 250 million players in more than two hundred countries, making it the world's most popular sport. The laws of the game were originally codified in England by the Football Association in 1863.

In the United States, what is now known as American football evolved from the sport of rugby football, and the first game was played in 1869. The San Francisco 49ers team was founded in 1946 and joined the National Football League, the NFL, in 1949. The team's name came from the prospectors who arrived in Northern California during the 1849 gold rush. To date, the San Francisco 49ers have won five Super Bowls. The team has many local fans, including this man, who was selling vegetables at the Heart of the City Farmers' Market, located at the United Nations Plaza.

The San Francisco Conference, formerly the United Nations Conference on International Organization, convened April-June 1945. The conference laid a foundation for the international organization known as the United Nation. It started with fifty countries, which fought Nazi Germany and currently has 193 member states. Since football (soccer) is played in 226 countries, it is a really unifying sport.

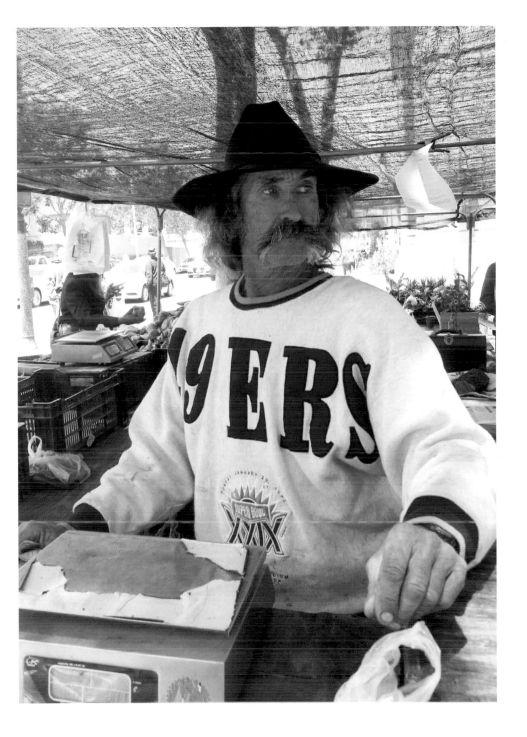

17

FLOWERS

Have you ever asked yourself why people love flowers? Perhaps humans have inherited an appreciation for beauty from the first woman, Eve, who "perceived that the tree was good for eating and that it was a delight to the eyes" (Genesis 3:6). And since the first task of her husband, Adam, was to take care of the garden, it was obvious that he planted the flowers as well.

Actually, scientists have concluded that flowering plants emerged on the planet more than 160 million years ago. Today more than 300,000 species of flowers are known to exist.

If you want to see incredible bouquets and flower arrangements, you have to visit the annual flower show at the de Young Museum of San Francisco. Or if you really want to see flowers without leaving the house, you can just watch *Most Beautiful Gardens in the World* on YouTube. And if you want to give a beautiful bouquet to someone special, the farmers market is one of the places to find one.

I met the happy flower seller at the Ferry Plaza Farmers Market on the Embarcadero. Like flowerbeds, the Embarcadero was filled with earth. It was constructed atop an engineered seawall on reclaimed land.

There are twenty-four Farmers Markets in San Francisco. The first one opened on August 12th, 1943 on the vacant lot of Market Street and Duboce Avenue. Apples were selling for three cents a pound, while pears were four and a half cents a pound, before the market officially opened.

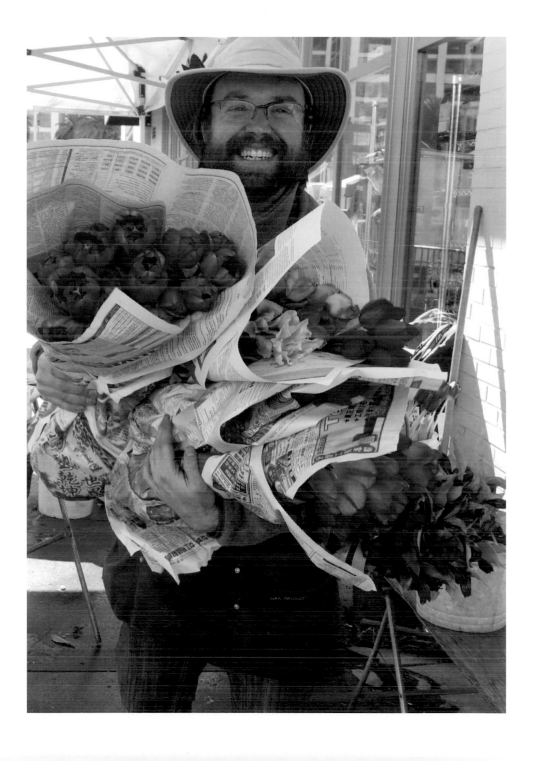

18

SUNGLASSES

You would probably be confused if, on a sunny day, someone were to ask you: "Where are your cheaters?" Well, in the early twentieth century, the word "cheaters" was a slang term for sunglasses.

The protective devices that we all call "sunglasses" have been known from the prehistoric times and were made from various materials including flat panes of smoky quartz. In the nineteenth and early twentieth centuries, doctors prescribed yellow/amber or brown-tinted spectacles for people with syphilis. Inexpensive mass-produced sunglasses were introduced to America by Sam Foster in 1929. In the early 1920s, the use of sunglasses became more widespread especially among movie stars. They needed protection from their fans as well as a way to hide red eyes caused by the powerful arc lamps used on the set.

I found all of this information on the Web in Wikipedia. In addition to the sunglasses' functionality, they became a fashion statement or a fun accessory. I noticed the funny-looking sunglasses on this man, who was sitting in the café shop next to Macy's on O'Farrell Street. Only after I took the shot did I read the words on his T-shirt.

Jasper O'Farrell (1817-1875) was the first surveyor for San Francisco. He designed the "grand promenade" that became today's Market Street. He was also influential in naming streets including Market, Lombard, Chestnut, Filbert, and Pine.

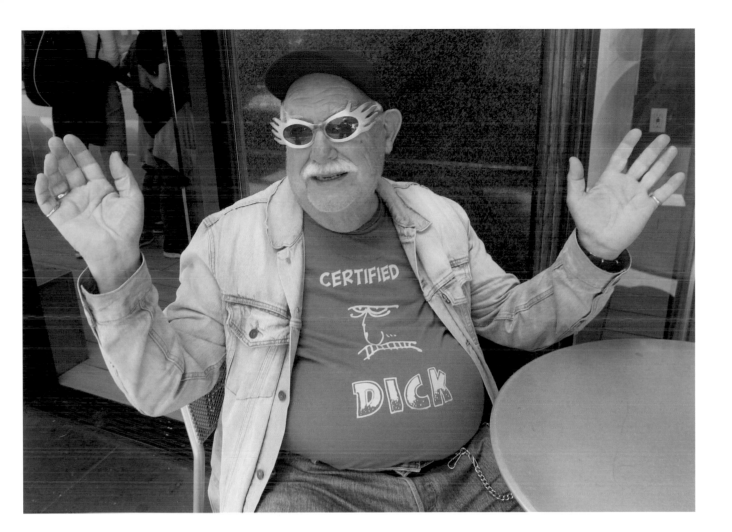

19

JOY

According to the Merriam-Webster Dictionary, the definition of "joy" is *"a feeling of great happiness; success in doing, finding, or getting something."*

Since my children were small, I have told them: "It does not matter what you do as long as you enjoy it." In other words, I wanted each of them to become a joyful person. But what does it take to experience joy? And what does it mean when we say we "enjoy something" or "enjoy being with someone"? I find these questions difficult to answer.

Do you know what makes you joyful? For instance, will finishing this book give me joy? Will reading it bring you joy? And will I enjoy finishing the book if I enjoy the process of making it just as much? Though I enjoy what I do, I may not be jumping for joy or even showing my joy externally. But it gives me joy just to think about you enjoying this book. Thus, I'm sharing my joy with you. It seems that the woman I encountered in Mission Dolores Park takes joy in playing on the slide with her children.

The park, which is named for nearby Mission Dolores, is situated on the land that was once a Jewish cemetery. The city bought the property in 1905. After the 1906 earthquake, the site was used to shelter 1,600 homeless San Franciscans who lived in tents on this site.

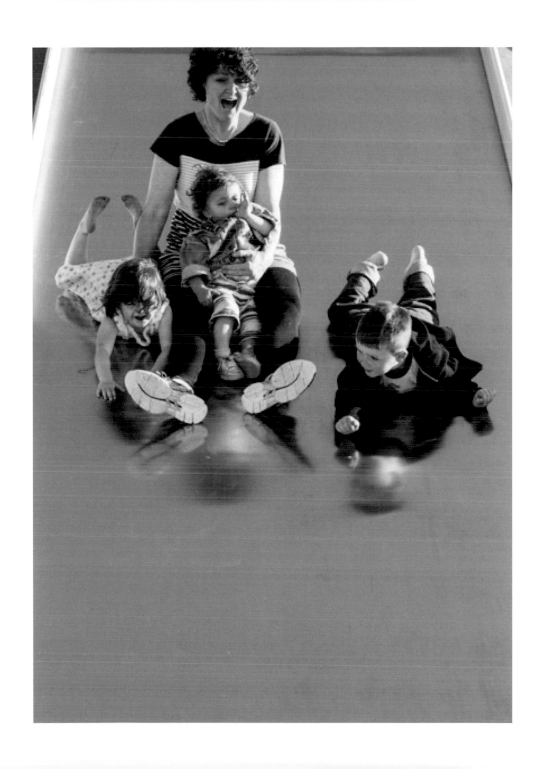

20

STRANGERS

In the past during our travels, as I would photograph people on the streets, my wife, Elfa, would ask, "Why do you photograph strangers?" I did not know how to answer this question. I like people, and seeing those "strangers" through my lens was my way of connecting with them; my camera is simply a tool with which to accomplish this process.

Some photographers photograph old buildings, which do not change and might still be in the same place in years to come. People are never the same. Their expressions, colors, gestures, locations, the way they are lit—it all draws my eyes. I want to capture the fleeting moment, which I know will never repeat itself.

The young man I encountered on the corner of Vicente Street and West Portal Avenue had a particular look. When I lifted my camera, he looked at me playfully. He had no idea that his image would end up in this book one day.

The names of the streets in the Sunset and Richmond districts of San Francisco were arranged in alphabetical order and named after important people who are strangers to us today. Vicente was probably named after Vicente Yanez Pinzon, who was a Spanish navigator and explorer, who sailed with Christopher Columbus on the first voyage to the New World.

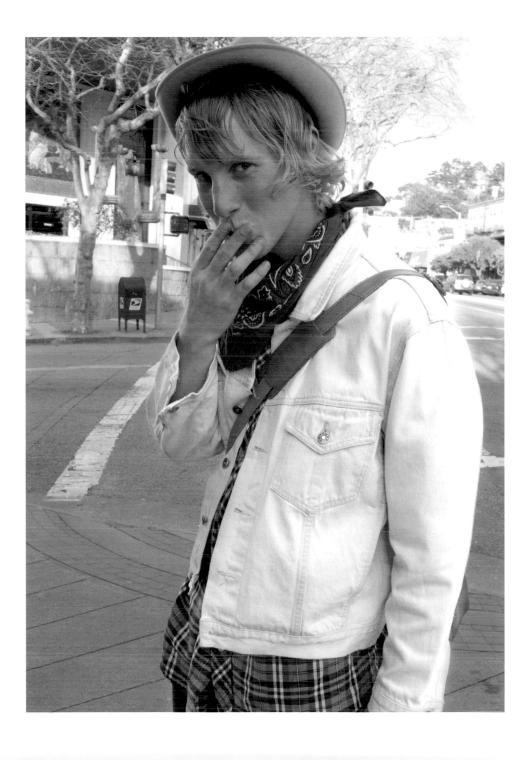

21

CHINATOWN

The oldest Chinatown in North America is the one in San Francisco, and it is the largest Chinese community outside of Asia. In 1848, two men and one woman arrived in San Francisco from China on the USS *Eagle*. It was only a year after Yerba Buena, a small settlement with a population of about 812 people, was renamed San Francisco.

And then it happened. In 1848, gold was discovered at Sutter's Mill. By December 1849, the population of San Francisco grew to 25,000, which included immigrants from China. Due to discrimination and repressive legislation limiting where these immigrants could live and work, Chinese laborers moved from the gold mines to the neighborhood that became known as Chinatown. As of 2012, about 21 percent of San Francisco's population—about 150,000 people—was of Chinese descent, with about half of them living in Chinatown. It is not surprising that the area retains a very specific flair.

In the center of Chinatown is Portsmouth Square, which was a waterfront years ago. This is where Captain John Montgomery disembarked from the war sloop Portsmouth in 1846 and raised the American flag. After the land was filled, this area became the site of a small park, where local residents now gather to relax and to play cards.

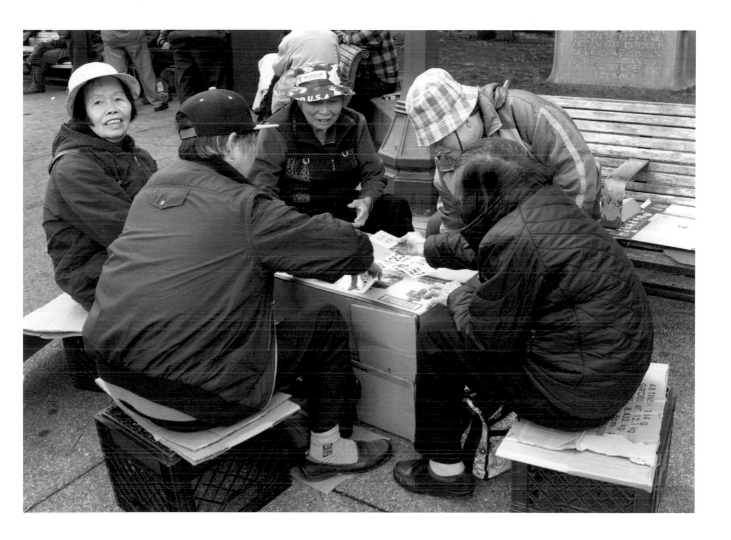

TOURISTS

Tourism is a huge business in San Francisco, the most beautiful city in the world.

According to a headline in the *San Francisco Business Times* article on March 27, 2014, "San Francisco Tourism Spending Set New Record at 9.4 Billion Last Year." Through some research online, I learned that we had 16.5 million visitors in 2012. It is a remarkable number, since our population is only 840,000 people.

Some years ago, my wife and I played tourists. On our wedding anniversary, we rented a room in a hotel in downtown San Francisco (a twenty-minute drive from our home). For two days we did what tourists do and had great fun.

You can find tourists everywhere, one of the most popular areas is Chinatown, where I encountered this woman. She was trying to figure out how to get to Coit Tower, which is located at the top of Telegraph Hill. As her umbrella was pointing out, to get there, she had to cross North Beach (San Francisco's Little Italy). When was the last time you played tourist in San Francisco and visited these areas?

Coit tower, also known as Lillian Coit Memorial Tower, is a 210-foot tower in the Telegraph Hill neighborhood. Ms. Coit, who died in 1929, left a substantial bequest "for the purpose of adding to the beauty of the city I have always loved."

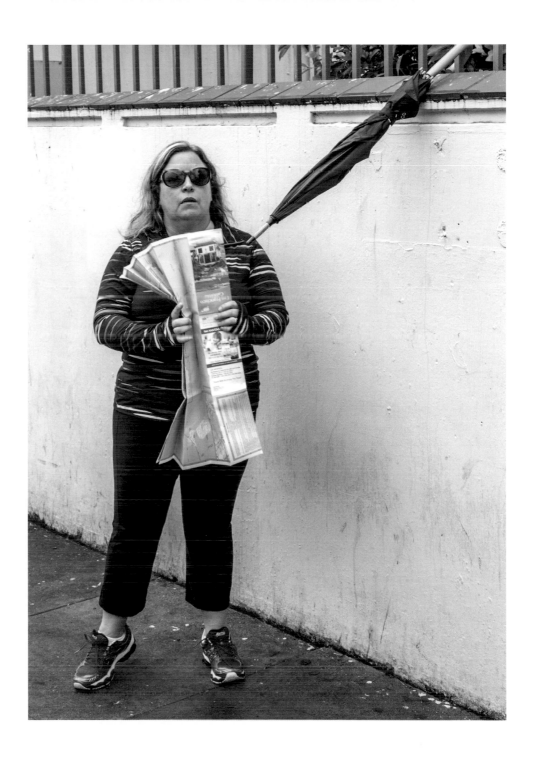

23

STREET PERFORMERS

Street performance, or busking, is the act of performing in public places for gratitude. From antiquity, buskers were men, women, and children who entertained passersby with acrobatics, balloon twisting, clowning, singing, dancing, and more. The term *busking* comes from the Spanish word *busker;* meaning, "to score," which in turn comes from the Indo-European word, *Bhudh-sko* meaning "to win; conquer."

Many famous artists began their careers as street performers. Among them are Rod Stewart, Tracy Chapman, Robin Williams, Pierce Brosnan, and B. B. King. The famous group Cirque du Soleil was started in 1984 by Guy Laliberté, a fire-breather and stilt-walker in Quebec.

Money magazine recently estimated that a performer working forty hours a week can make a salary of about $45,000 a year. That's not much by San Francisco standards. Nevertheless, you can see jugglers, musicians, and tap dancers downtown or at the Ferry Building, entertaining the crowds, just like this fellow whom I encountered on Market Street.

Street performance runs the gamut of entertainment. In his memoirs, Benjamin Franklin wrote that as a youngster in Boston in 1718 he would perform songs and read poetry on the streets. And the hippie counterculture of the 1960s staged "be-ins," which resembled present-day busker festivities.

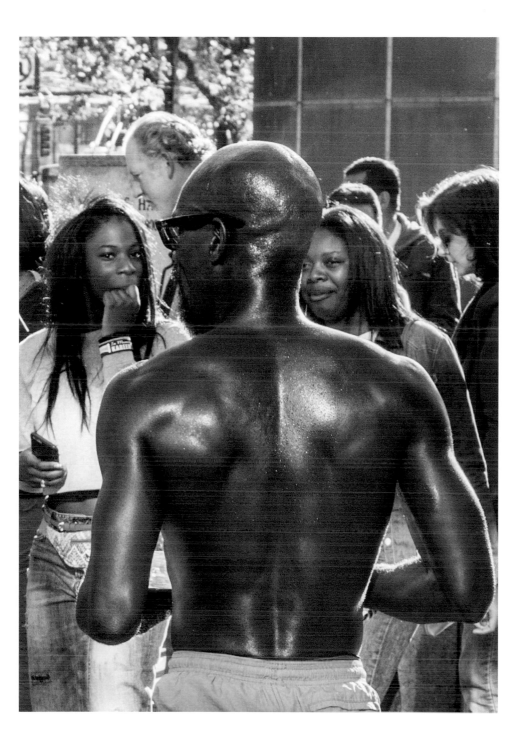

24

CHILDREN

Anyone who has children knows that they come to this world
to be our teachers. They always challenge us; they force us to be
our best. They constantly ask questions and do not accept "No"
for an answer. But most importantly, they remind us that life is
a game. After they grow up, they become our best friends and,
if we are lucky, at the end of our lives, when we start behaving
like children, they become our guardians. I encountered this boy
playing with a ball in Golden Gate Park.

*Golden Gate Park, which opened in 1871, gives children and adults
plenty of room to roam over its 1,017 acres of public grounds. It is
similar in shape to New York City's Central Park, but 20 percent
larger. When it was conceived in 1860, the area was covered
with dunes. Thanks to the efforts of John McLaren, who served as
superintendent of the Golden Gate Park for fifty-three years, today
millions of people can enjoy an incredible natural beauty.*

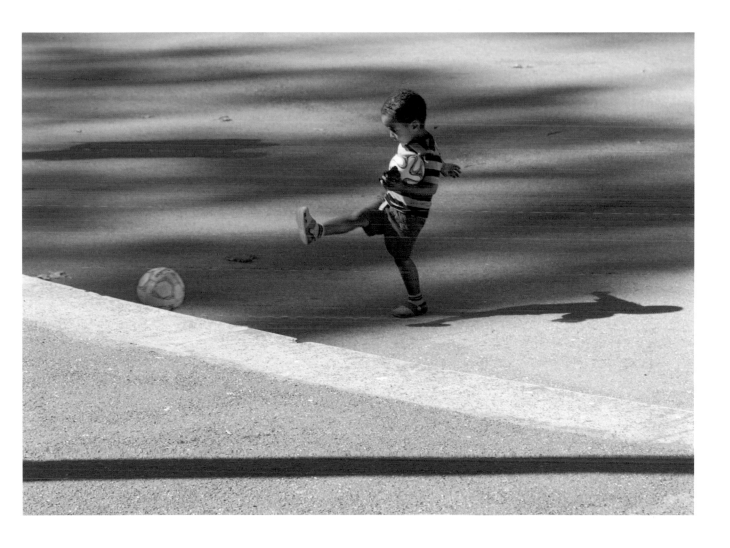

CELEBRATIONS

San Francisco, with its diversity of people from different countries, has many reasons and events to celebrate throughout the year.

It starts in February with the Chinese New Year Parade, called Spring Festival. The date changes every year since it is based on the Chinese lunisolar calendar. It is followed by St. Patrick's Day on March 17. Then there is the Cherry Blossom Festival in Japantown in mid-April, followed by Israel Independence Day celebration at the end of April. Then there is Mexican Cinco de Mayo in May, celebrated in the heart of the Mission District. At the end of June, San Franciscans celebrate LGBT—the lesbian, gay, bisexual, and transgender movement—with the Pride Parade. After a short summer holiday, the celebration continues with the San Francisco Greek Food Festival in mid-September. And then in November, before we begin getting ready for Thanksgiving, there is Mexican Día de Muertos, the Day of the Dead celebration. This holiday focuses on gathering for prayer, remembering friends and family members who have died, and helping support their spiritual journey. And at any good Day of the Dead celebration, people will show up wearing symbols of death, as did this mother and two daughters whom I met near Davies Symphony Hall.

Davies Symphony Hall was named after San Francisco benefactor Louise M. Davies, who in 1980 gave our city a $5 million gift to build a remarkable place where music is celebrated all the time.

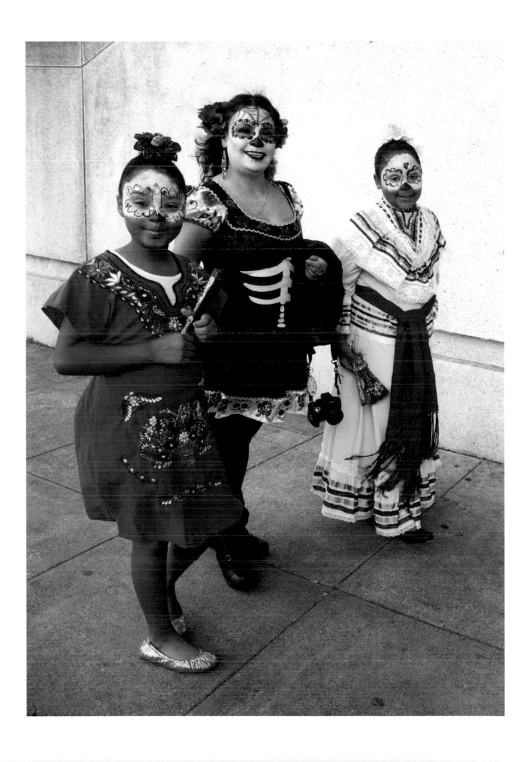

26

MAN'S BEST FRIEND

Many scientists agree that dogs were domesticated sometime between 13,000 and 30,000 years ago. The modern dog evolved from a now-extinct species of the European wolf. Although it is hard to obtain reliable figures for some countries, in 2012 the total number of dogs in the world was at least 525 million. The United States alone had more than 73 million dogs.

You have probably heard the expression: "A dog is a man's best friend." Supposedly Frederick II, King of Prussia, said that while referring to one of his Italian greyhounds as his best friend. The world canine organization (Federation Cynologique Internationale, or FCI) recognizes at least 339 breeds of dogs. The breeds are divided into ten groups, based upon the dog's purpose, size, or function.

We used to have dogs. After our Irish setter was killed by a car some years ago, we decided to adopt a dog with short legs. We chose a Welsh Corgi, who was our friend for more than thirteen years. We still dream that one day we might bring another dog into the family.

It is clear that the dog is our friend, but who is a friend to the dog? Dogs depend on humans to feed, shelter, and care for them. Do we always do the job? Some dogs are great friends to people on the go, like the one I encountered on Haight Street. The street was a birthplace for the hippie movement and is still home to many people who choose a very different lifestyle.

Haight Street is named after Henry H. Haight. While governor of California from 1867 until 1871, Haight established the University of California on March 23, 1868.

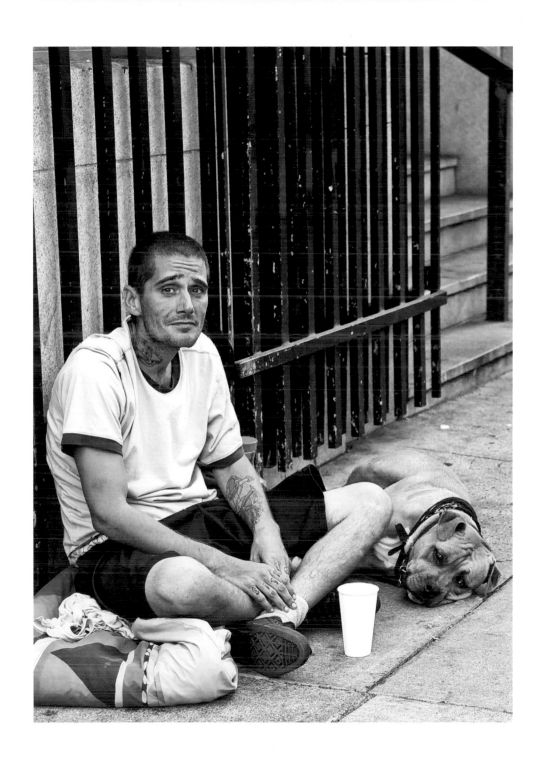

27

CRISSY FIELD

One day, while walking on Crissy Field Park, I came upon a man who builds sculptures from freestanding balanced rocks. It looked to me to be a remarkable skill, but, according to the sculptor, anyone can learn. Online I found a lot of interesting information. Apparently there is an annual Rock Stacking World Championship in Llano, Texas. One of the artists for whom rock balancing is a minor subject of his "Celebration With Nature" work, is Andy Goldsworthy. His latest sculpture in San Francisco called "Tree Fall," can be seen at the Presidio Park, and was installed in 2013.

San Francisco has more than sixty-five parks. They are divided among federal, state, city, and private ownerships. One of the parks, Crissy Field, is located at the site of the former Presidio military base, which was closed in 1989. The base's 1,491 acres became a park, and it is visited by more than five million people annually. Part of the base was an airstrip, which was named in memory of Major Dana H. Crissy, the base commander who died in an air crash in 1919.

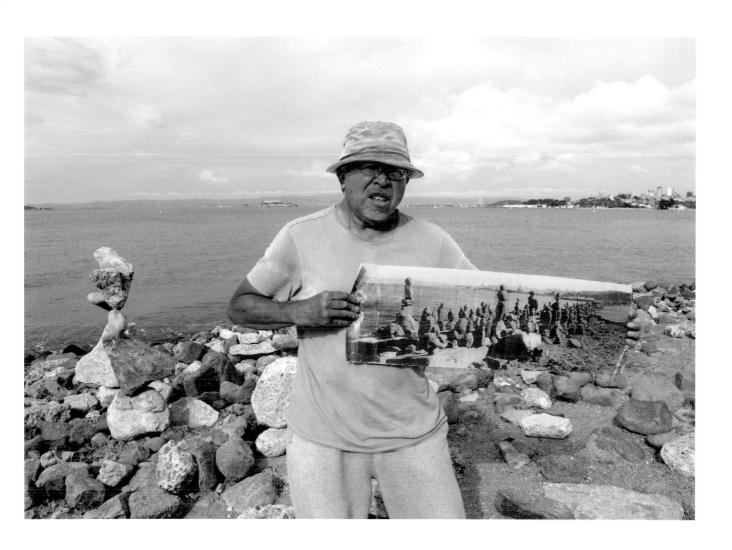

28

FURNITURE

One of the earliest uses of furniture dates between 3100 and 2500 BC and was discovered at Skara Brae village in the Orkney Islands in Scotland. But it is also known that furniture was used in ancient Egypt and Greece, as well as in Rome. Medieval furniture was very basic. Even in a wealthy household, chairs were rare; most people sat on stools and benches. Only in the sixteenth century did life become comfortable for the wealthy. And as time progressed, furniture became more finely decorated. But in the early nineteenth century, the poorest people slept on piles of straw because they could not afford beds. There is a fascinating account about the development of furniture in Bill Bryson's book *At Home: A Short History of Private Life*.

In our times, furniture became affordable and abundantly available. Some furniture even became part of an art installation decorating the former Hugo Hotel, which was located on the corner of Sixth and Howard streets. The installation, which was there from 1997, drew attention and became a well-known piece of the city's art. The building was demolished in 2014, but before that happened, I was fortunate to capture artist Brian Goggin while he was affixing the falling bed. The installation was most certainly a far cry from what William D. M. Howard, after whom this street was named, might have imagined "his" street would come to look like.

Howard, who came to Yerba Buena in 1846, then became a wealthy pillar of the community and San Francisco's first philanthropist.

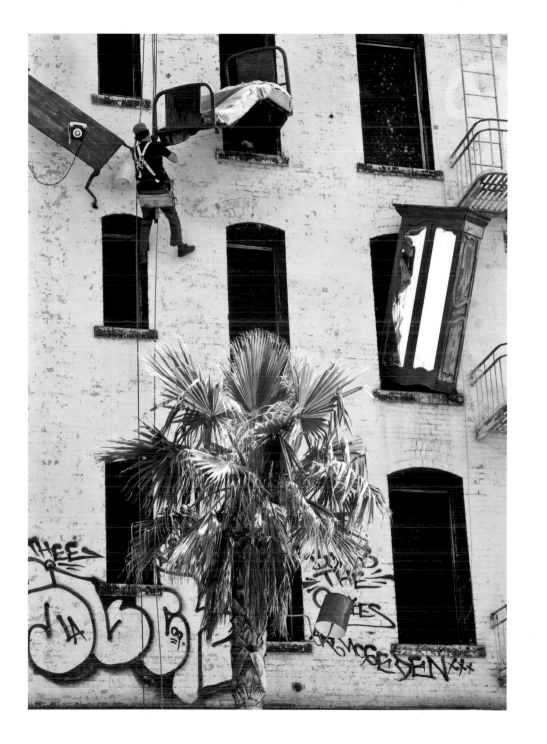

29

MAILMAN

It all started with the gold rush in 1848. In 1860, the population of San Francisco was 56,802; by 1900 it grew to 342,782. The demand for a faster way to get mail and other communications to and from the westernmost states was growing. There were a number of solutions. Three companies were created to fulfill this need: The Pony Express, Pike's Peak Express Company, and Overall Mail Company. People and mail were transported in horse-driven coaches. Later, trains and airplanes significantly shortened the delivery time and increased convenience.

But after mail was received at a specific location, it had to be distributed to individual addressees. The U.S. Postal Services was formed on July 25, 1775, with the appointment of Benjamin Franklin as the first U.S. postmaster general. Today the U.S. Post Office competes for business with Federal Express (FedEx), United Parcel Service (UPS), and soon with delivery drones. It is not surprising to learn that to increase revenue, the U.S. Postal Service is considering alcohol delivery. I met a hard-working mailman on the steps of Dixie Alley, which is probably one of the shortest and steepest streets in San Francisco.

Apparently a strange connection with other parts of the United States, old names keep our history alive. "Dixie" used to be the popular nickname of the Southern states, especially those that belonged to the Confederacy (1860–1865).

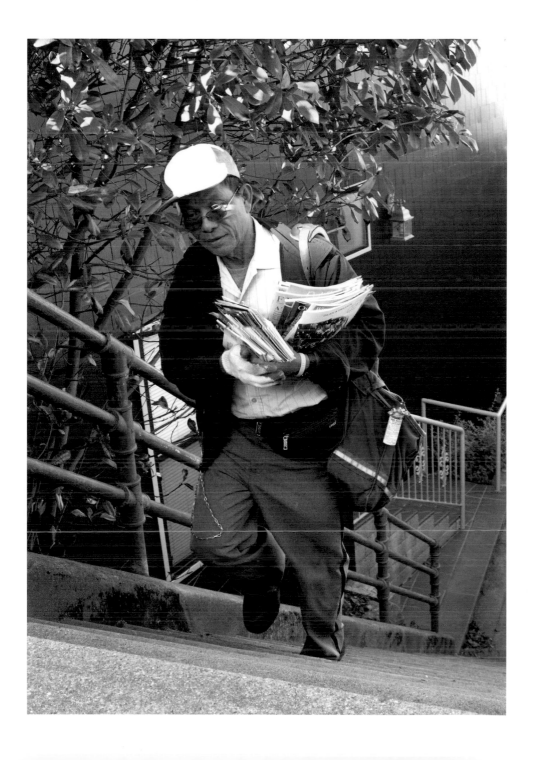

30

EATING HABITS

Market Street at the intersection of Fourth and Powell streets, attracts a lot of people who promote their ideas. It is probably the busiest corner in the city.

This is where I met a man who promotes veganism. Vegans do not eat any animal products or animal-derived substances, including eggs and dairy products. Our family decided to become vegetarians over forty years ago when we lived in Israel. One day we stopped eating meat and fish. Shortly after coming to San Francisco, we visited a nutritionist, who suggested that for health benefits, we should eat fish. Thus, we became pesco-vegetarians.

Our older daughter, Alona, eats everything but has recently started to be more aware of the quality of food. Our youngest daughter, Tamar, is still a vegetarian. Sometimes people ask me "Don't you crave meat?" I do not. And I feel great most of the time.

When I googled "best vegetarian restaurants in San Francisco," it showed 4611 results.

In 1826, French gastronome Jean-Anthelme Brillat-Savarin wrote, "Tell me what you eat, and I will tell you what you are."

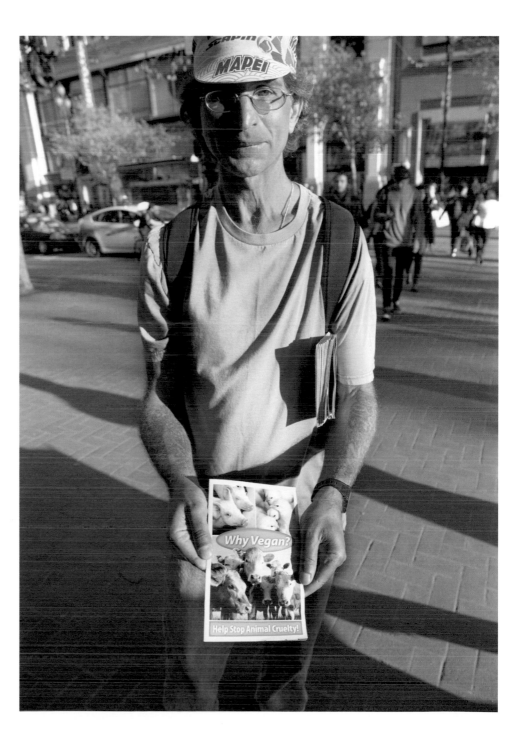

31

SLOW TRAFFIC

Anyone who drives a car in San Francisco is sure to come up against traffic congestion—and with good reason. The city's population is about 840,000, and another approximately 500,000 people commute into it daily. The number of registered cars alone is also approaching 500,000. We live in a beautiful city, but the roads were designed when the population was less than one hundred thousand, and the streets had practically no cars on them. Today's drivers must navigate streets that need repair, while sharing them with bicyclists.

What this means for the pedestrians: Wear bright clothes and cross streets slowly, one step at a time, like this woman I encountered on O'Farrell and Fillmore street, in the heart of what was known as the "Jazz District."

The Fillmore district was created in the 1880s. It evolved first as being the center of Jewish life after the 1906 earthquake. Then Japanese immigrants moved in but was later replaced by African-Americans. The area became a national center for jazz during the 1940s and 1950s, when it was known as Harlem of the West.

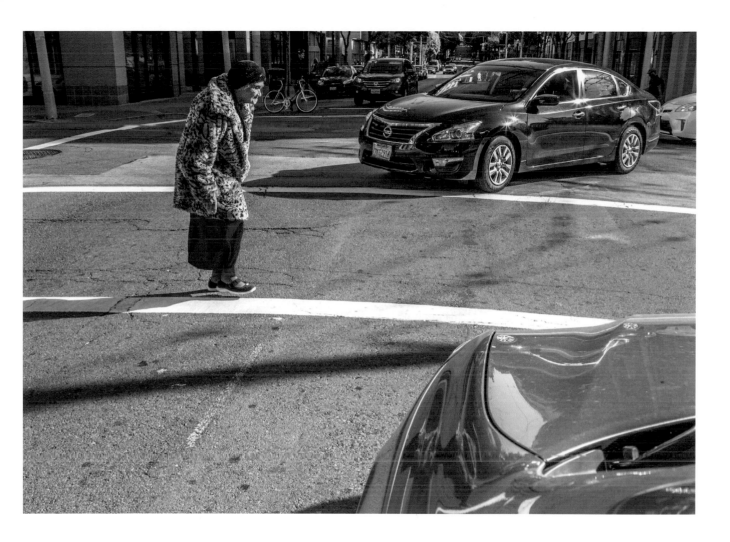

32

CIGARETTE SMOKING

I picked up smoking at the age of five and quit at age seven. My parents did not smoke, but my father kept small cigars for guests in a cupboard. One day, when I was alone at home, I climbed up and took out the pack. I pulled out one cigar, stuck it into my mouth, lit a match, and tried to inhale. Nothing happened. (I didn't know about cutting the end.)

I did eventually learn how to smoke. With a few delinquent kids in our neighborhood, the rest of us had cigarettes readily available. My life as a smoker was short lived. When I was in the first grade, I was caught smoking. I do not remember what my father told me or did to me (although a childhood friend, who was our neighbor, recently recalled that he heard my loud screams the day I got caught). Whatever transpired, it left a lasting impression. No smoking for me.

It seems that not everyone is so fortunate. More than 20 percent of Americans smoke, including the woman I encountered in downtown San Francisco on Stockton Street.

The street is named after Robert F. Stockton, who, while serving in the United States Navy, made a notable contribution to the capture of California during the Mexican-American War. He probably did not smoke, since, when he died in 1866, he was seventy-one.

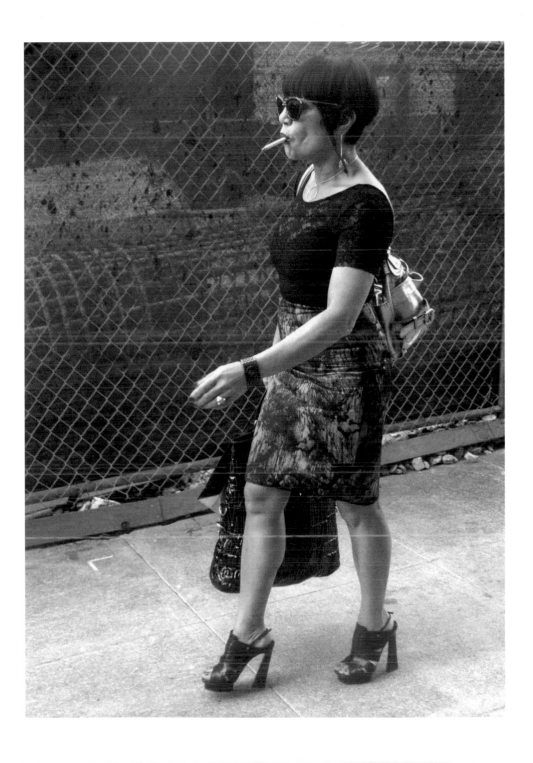

33

SADNESS

In the famous lyrics of one of Bobby McFerrin's songs, he tells us "Don't Worry, Be Happy." Those words are wonderful, but can we be happy and avoid worry all the time? Of course not. Besides, to experience happiness, we also need to know the feeling of sadness. This feeling is also sometimes called a heavy heart. What causes this heaviness? My feeling is that it is our own thoughts, our reaction to the world outside of ourselves. What we interpret as feelings of disadvantage, loss, despair, helplessness, disappointment, and sorrow are real, but they are passing. It is our responsibility to seek joy after our feelings of sadness leave us.

I encountered this man who makes balloon sculptures downtown on Market Street. Sculptured balloons can take sadness away from many children. But can they do the same for adults?

Market Street was designed by Jasper O'Farrell, the first surveyor of the area called Yerba Buena, before it became San Francisco in 1847. He wanted the new city to have a "grand promenade." The street, which had 120 feet between property lines and cut the city on an angle, became a main thoroughfare, stretching three miles.

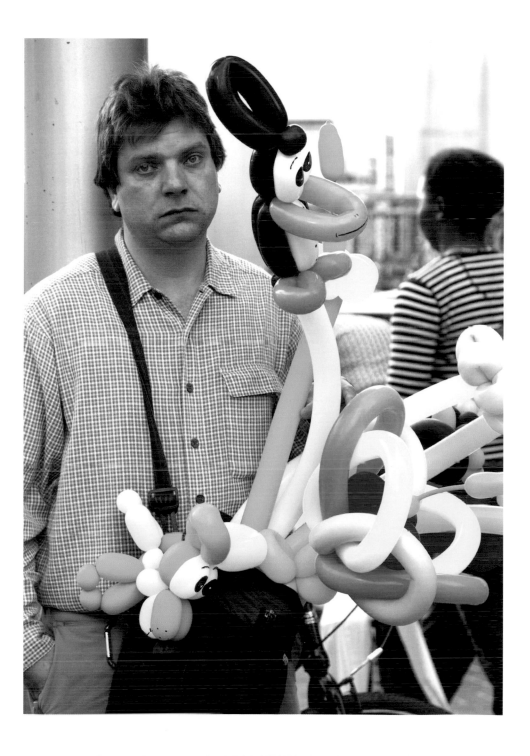

34

SISTERS

Shortly after we moved to San Francisco in 1980, our new friends took us around to show us the local attractions. We were taken everywhere—from Ghirardelli Square, where we ate ice cream, to the Castro area, where we saw men walking, holding hands, and kissing on the street. It was not something we were yet accustomed to seeing.

Years later, driving down Market Street, I suddenly noticed a group of men dressed in white. I could not pass this photo opportunity. I found a place to park, and started shooting. I had no idea who those people were or why they were dressed and made-up as they were. But I had good models who did not mind being photographed. Later I found out that my subjects were the Sisters of Perpetual Indulgence. According to Wikipedia, at their inception in 1979, a small group of gay men in San Francisco began wearing nun habits to draw attention to social conflicts and problems in the Castro District.

The neighborhood, now known as the Castro, was created in 1887, named after General Jose Castro (1808–1860), a leader of the Mexican opposition to U.S. rule, in California. It is located in Eureka Valley. During the 1960s and 1970s, the Castro District transformed from a working-class neighborhood into one of the prominent symbols of the lesbian, gay, bisexual, and transgender (LGBT) community. It is known as San Francisco's gay village.

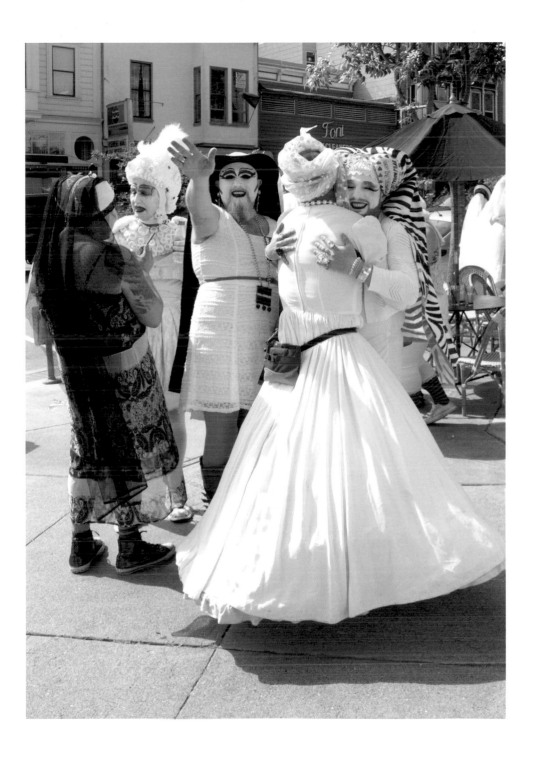

35

BALANCE

Keeping the balance or being a balanced person is probably the biggest challenge we human beings face. After all, from our birth to the end of our journey in this world, we are influenced by outside forces. And perhaps, finding balance is exactly what our purpose in life is. Balance is often defined as "equal distribution of weight" or as "correct proportion." But how can we find balance between our education, work, children, fun, health, and the myriad of other life events? The young man I encountered at the San Francisco Ferry pier, has at least found a way to balance his body.

From 1850 until the opening of the Bay Bridge in 1936, the ferry was the only way to keep the "balance" between Oakland and San Francisco.

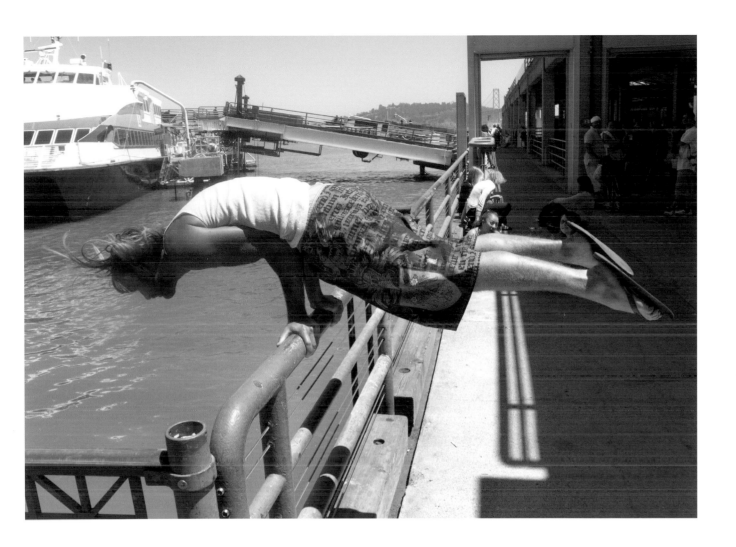

36

BIRTHDAY

The birthday celebration was mentioned in the Bible. "Now the third day was Pharaoh's birthday, and he gave a feast for all of his officials" (Genesis 40:20). The Greeks, who probably adopted the tradition of celebrating birthdays from the Egyptians, added the idea of putting candles onto cakes for the celebration. The ancient Romans were the first to celebrate birthdays for the common man, although they did not celebrate them for women.

Christians initially considered birthdays to be a pagan ritual, but then they began to celebrate the birthday of Jesus. Birthday celebrations for children began in Germany in the late eighteenth century, and that was when the tradition of adding a candle for each year—plus one more to symbolize the hope of living for at least one more year—began. About that time, the Industrial Revolution, among other things, lowered the price of cakes through mass production. Thus, more people could afford to celebrate their birthdays.

This woman, whom I encountered in front of San Francisco's Ferry Building, seemed to be enjoying her grandchild's birthday. I often visit this area, which offers a great view and is good for walking along the water.

The Ferry Building was built in 1898 and survived both the 1906 and 1989 earthquakes. Until the completion of the Bay Bridge in 1936, the Ferry Building was the second busiest transit terminal in the world, second only to one in London.

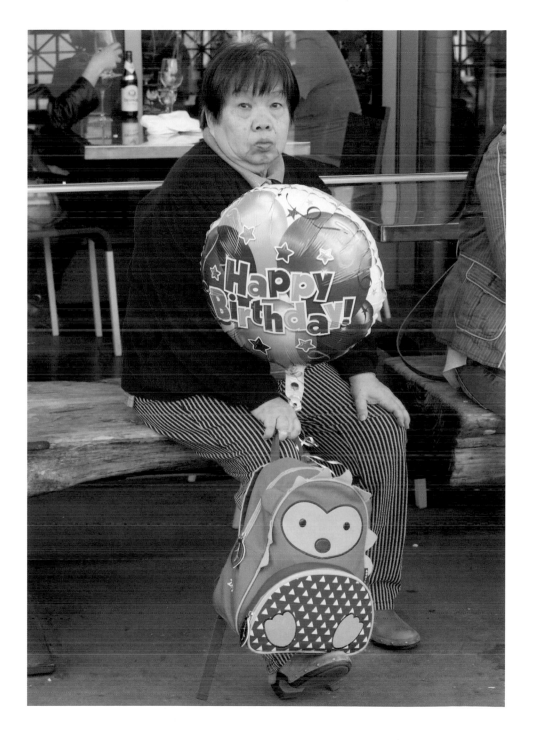

37

MURALS

Since prehistoric times, people have expressed their creativity by drawing on walls. Through the years, artists' skills and materials improved, and the number of decorated walls increased. During the Renaissance, it was common for famous artists to paint murals inside churches and cathedrals. During the 1930s, the well-known Mexican muralist Diego Rivera was commissioned to paint huge murals on the walls of Rockefeller Center in New York. In San Francisco, Rivera was asked to paint three frescos. One is in the San Francisco Art Institute, another is at the San Francisco Stock Exchange, and the third one is in the City College. There is also a Diego Rivera–inspired mural by Jane Berlandina, in Coit Tower on Telegraph Hill, and a mural by Lucien Labaudt in the San Francisco Beach Chalet, located on the Great Highway by the ocean.

In more recent years, mural's have moved out onto the streets. Many of them can be seen in the Mission District, which became a virtual outdoor art gallery. Many artists painted the walls of Balmy Alley located between Twenty-fourth and Twenty-fifth streets. I met this mural artist during his creative process on the corner of Geary and Fillmore Streets.

Fillmore Street is named after Millard Fillmore, who was the thirteenth president of the United States serving from 1850 to 1853.

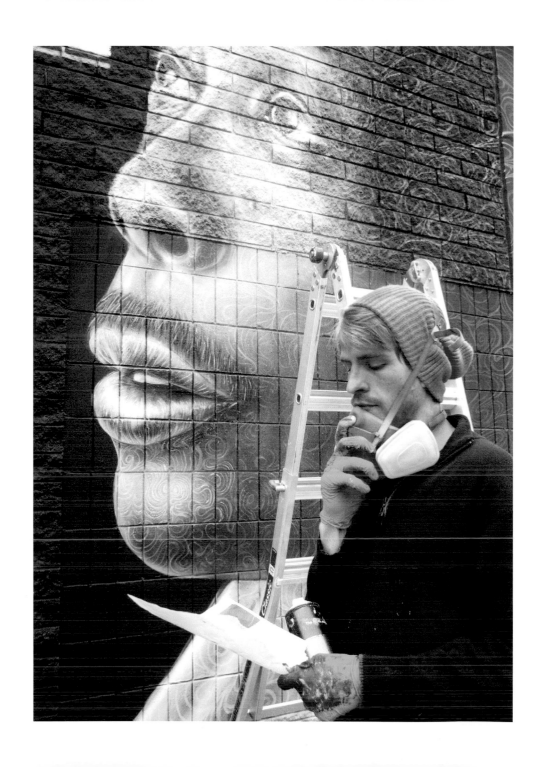

38

GIANTS

You do not have to be a baseball enthusiast or live in the San Francisco Bay Area to know about the San Francisco Giants baseball team.

What you probably did not know is that giants were mentioned in the Bible a number of times as a separate race, under the name of Nephelim. After returning from spying on the Promised Land, a group of children of Israel brought an evil report saying, "There we saw the Nephelim, the sons of the giant" (Numbers 13:23). It is translated from the Hebrew word, which means "the huge one. " I encountered this giant woman on Van Ness Avenue. She seemed to be part of a celebration concert at Davis Symphony for the Mexican holiday, Dia de Muertos – or Day of the Dead.

James Van Ness, after whom the street is named, became the seventh mayor of San Francisco in 1855. He was one of the giants on whose shoulders our city was built.

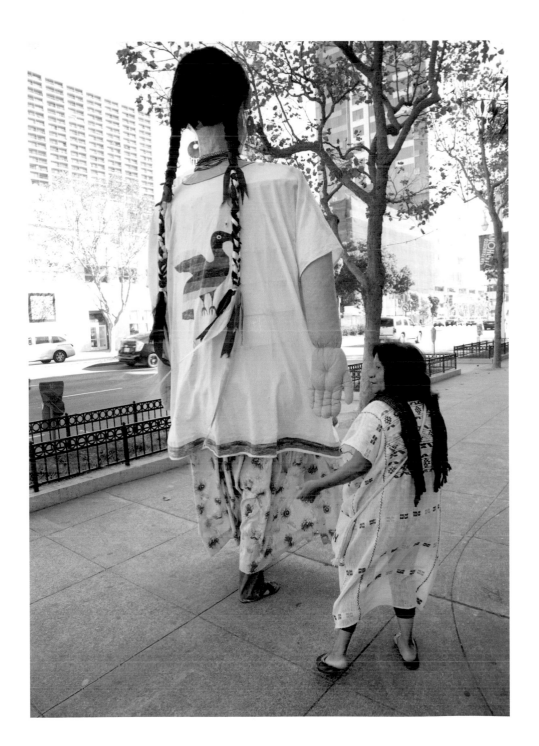

39

MANHOOD

According to the *Merriam-Webster Dictionary*, the definition of *Manhood* is "the qualities (such as strength and courage) that are expected in a man." In Yiddish, the language of East-European Jews, the word *mensch*, associated with manhood, means "a person of integrity and honor." But what is the path to manhood? When I turned thirteen, I recieved a wristwatch from my father at my bar mitzvah, the time a Jewish boy becomes resposible for his actions. In some aboriginal societies, there is rite of passage when boys are sent to the wilderness by themselves.

But apparently there is yet another way to become a man (or a mensch). According to the ad I photographed in the underground passage to Muni Metro, you can "Purchase a one-way ticket to manhood at the Macy's men's store!"

Macy's West was established in San Francisco in 1866 as O'Connor, Moffat, Kean Co. It was purchased in 1945 by R. H. Macy & Company from New York and became known as Macy's.

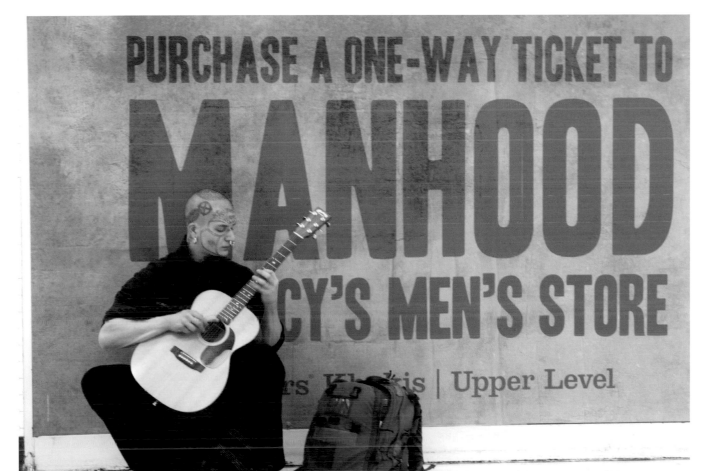

40

BAKING

When I grew up in Riga, I had an aunt who was a very good baker. I told her that when I got married, I wanted her to teach my wife to bake. As it turned out, there was no need for that. My wife, Elfa, is a fine baker herself. Soon after we met, she baked cookies that are called, "House's Friends." After I tasted them, I was hooked. Forty-nine years later, she still bakes them on special occasions. Our daughter Tamar is a good baker as well, and for a while, she was making extra cash by selling her cupcakes to offices and coffee shops.

If you want to have a great light lunch, taste something exquisitely European, and see your dessert made from scratch in front of you, there is only one place in San Francisco to go—20th Century Cafe. This is one of my favorite places to take friends when I am not counting calories. The owner, Michelle Polzine, is an excellent baker and is doing a remarkable job, with assistance from Drake Johns, providing San Franciscans with delicious pastries.

I discovered the cafe one day driving on Gough Street, when I suddenly saw a pushcart on the corner of Oak Street at the entrance to the cafe. I decided to check it out, and here is the result.

Charles H. Gough, after whom Gough Street was named, was a milkman in 1850. He later became a contractor and a member of the committee assigned to develop the Western Addition.

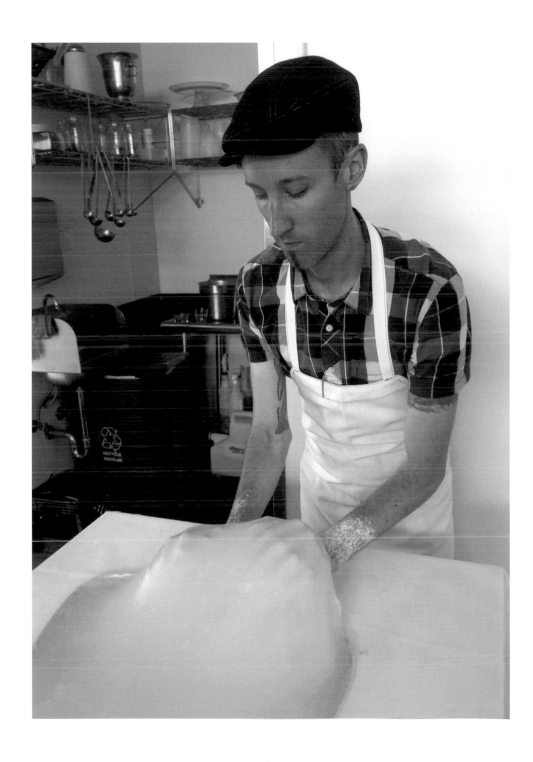

41

FUN

I hope you had a lot of fun reading my stories and seeing my images in this little book. I definitely had a lot of fun putting them together. But neither of us would have any fun if it were not for a group of talented people who helped make this project a reality. Jasmine Moser helped me select forty-two images from the thousands in my computer and made them available for the next step. After that, Vladimir Rodstein made sense from my handwritten notes, my daughter Tamar Kagan edited my writing, Darren Young designed the cover and assembled everything into this book, and Amy Bauman did the final editing. Other people who helped me make the book include Alona Kagan (my older daughter), David Sajadi, Nicolo Sertorio, Jessica Brands Lifland, Samantha Regala, Bruna Stude, Irit Axelrod, and Batya Aloush.

But the most important partner in the process is always my wife, Elfa. During a workshop with the renowned photographer Jay Maisel, he asked his students, "How do you know if you have a good image?" My response was: "When my wife likes it." This time, when I asked her which photo we should put on the cover of the book, she responded: "I have difficulty choosing; I like all of them." I hope you do as well.

Now back to how to have fun: According to the Internet, there are between four and twelve ways to have fun. I suspect that this young woman, who was playing with a Hula-Hoop on the corner of Masonic Avenue and Haight Street, was having fun without going on the Internet.

Masonic Avenue got its name because it originally ran alongside the Masonic Cemetery. In 1914, realizing that a lot of dead people were occupying valuable real estate, the city decided to relocate cemeteries to Colma, five miles south of San Francisco.

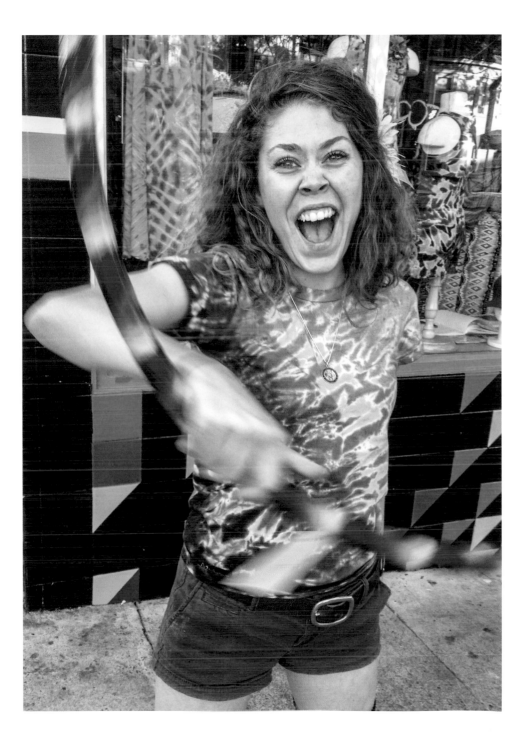

42

WISDOM

William Shakespeare wrote: "A fool thinks himself to be wise, but a wise man knows himself to be a fool."

In my view, some people are born wise, while others find wisdom in a book. To support this thought, well-known literary critic Harold Bloom wrote a book titled *Where Shall Wisdom Be Found?*

To become wiser, I take advantage of all of the resources for finding interesting books: the San Francisco Public Library as well as bookstores (online purchases included). I especially enjoy going to used bookstores. It is fun to browse the photography section and to find beautiful, out-of-print books.

For my stories in this book, I used information from *Historic San Francisco* by Rand Richards, *San Francisco Street Secrets* by David B. Eames, and *Streets of San Francisco* by Louis K. Loewenstein. Wikipedia helped me find a lot of valuable details about people and places.

If you are interested in reading about San Francisco's history, do not miss the fascinating *Cool Gray City of Love: 49 Views of San Francisco*, by Gary Kamiya. I also enjoyed stories in *Why Is That Bridge Orange?* by Art Peterson, and *A Short History of San Francisco* by Tom Cole.

I took this photo in Adobe Books, which has since closed. It was located on Sixteenth Street, across from the Roxie Theater, the oldest continuously operating movie theater in San Francisco. The Roxie opened its doors in 1909 and still shows interesting films that you cannot see in other places.

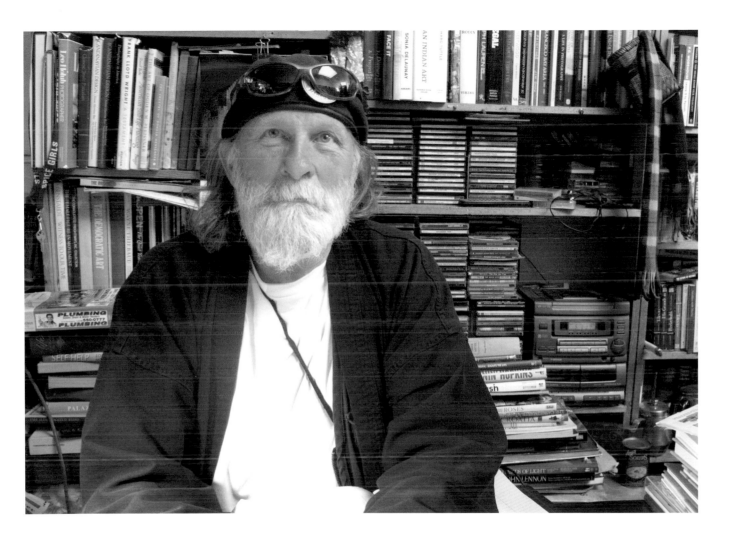

CONCLUSION

I am confident that you enjoyed *42 Encounters*™. The book actually includes two bonus images. One of them, on the cover of the book is a cropped version of the image on page 72, and another is my self-portrait pictured here.

I plan to use all proceeds from the sale of these books to create a fund that we will use to help young people and their parents learn how to see the beauty of our world through the lens of a camera (or a smartphone). My hope is that my photography will encourage you to go out and meet more people and to use your camera to convert strangers into friends. The philosophy of "encounter photography" is to be ready, to see who you encounter, to frame the image, to capture it, and to move on. Most of the time, I do not know the people whose images I've captured. If you recognize yourself or someone else in this book, please contact me. I will be very happy to mail you an 8"x10" print of "your" photo, signed by the author (me).

You can see more of my photography and read more about "My Encounters™" at www.mannykagan.com. Share it with a friend.

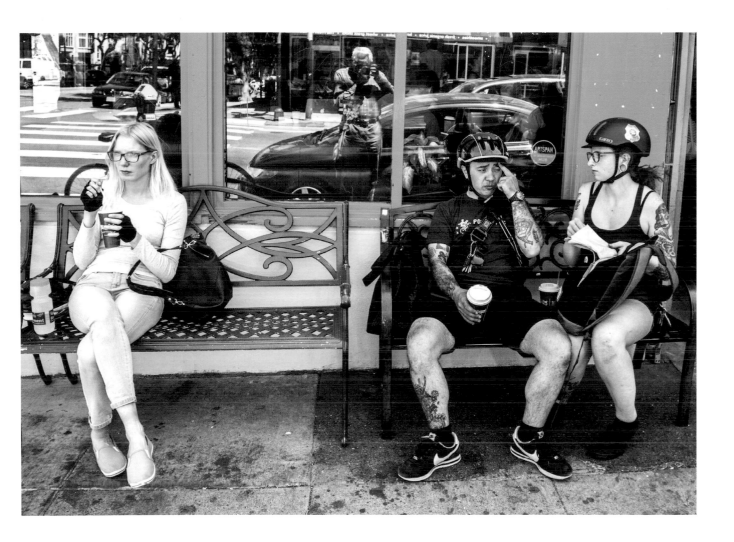